PURE LAND · 淨土

許 朝 益 攝 影 集

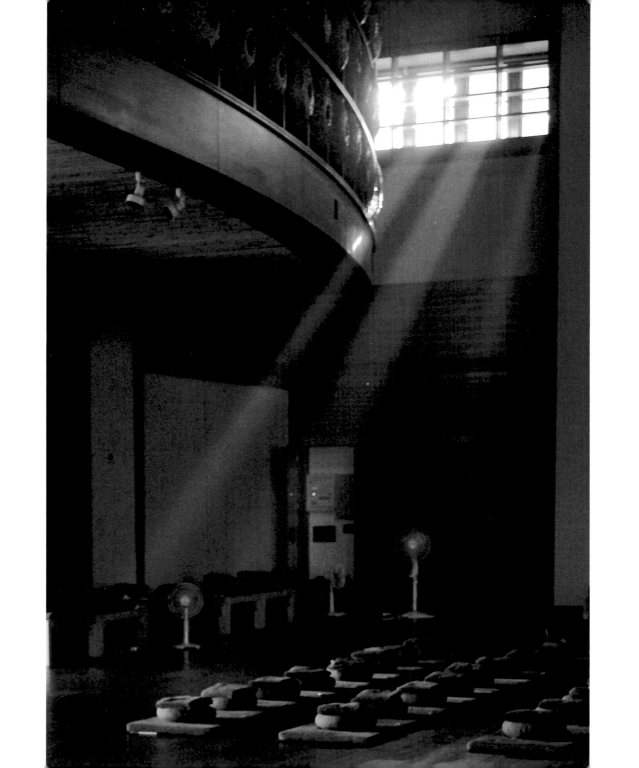

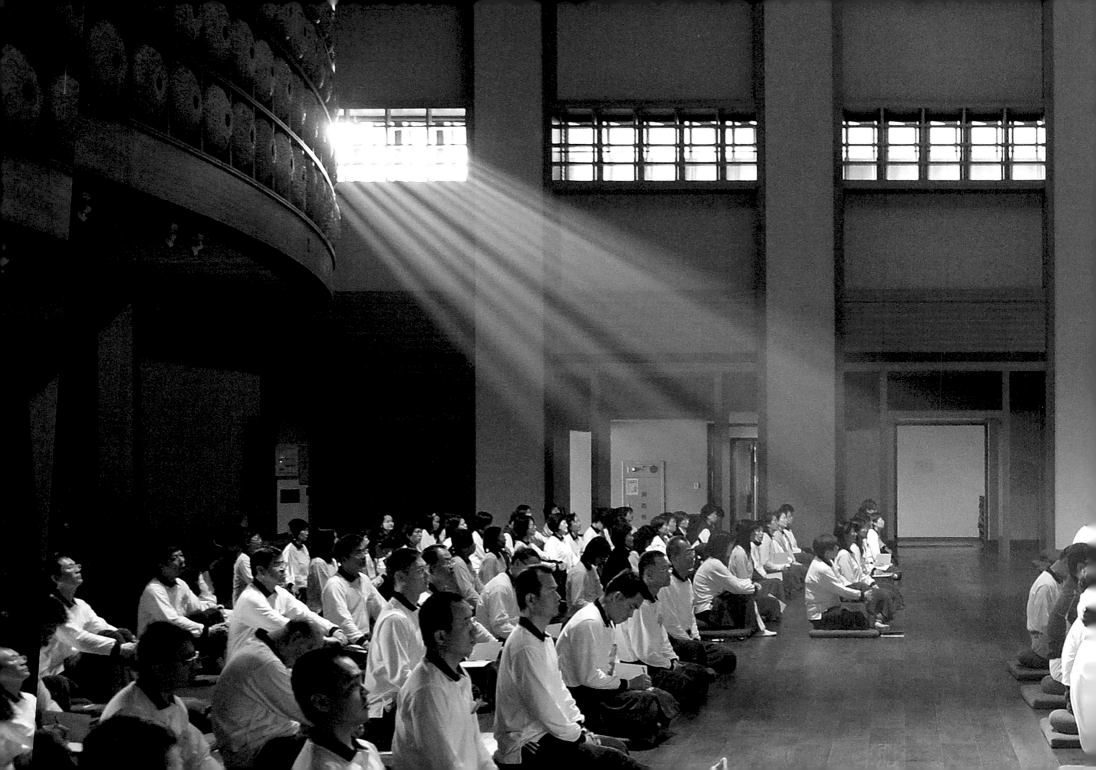

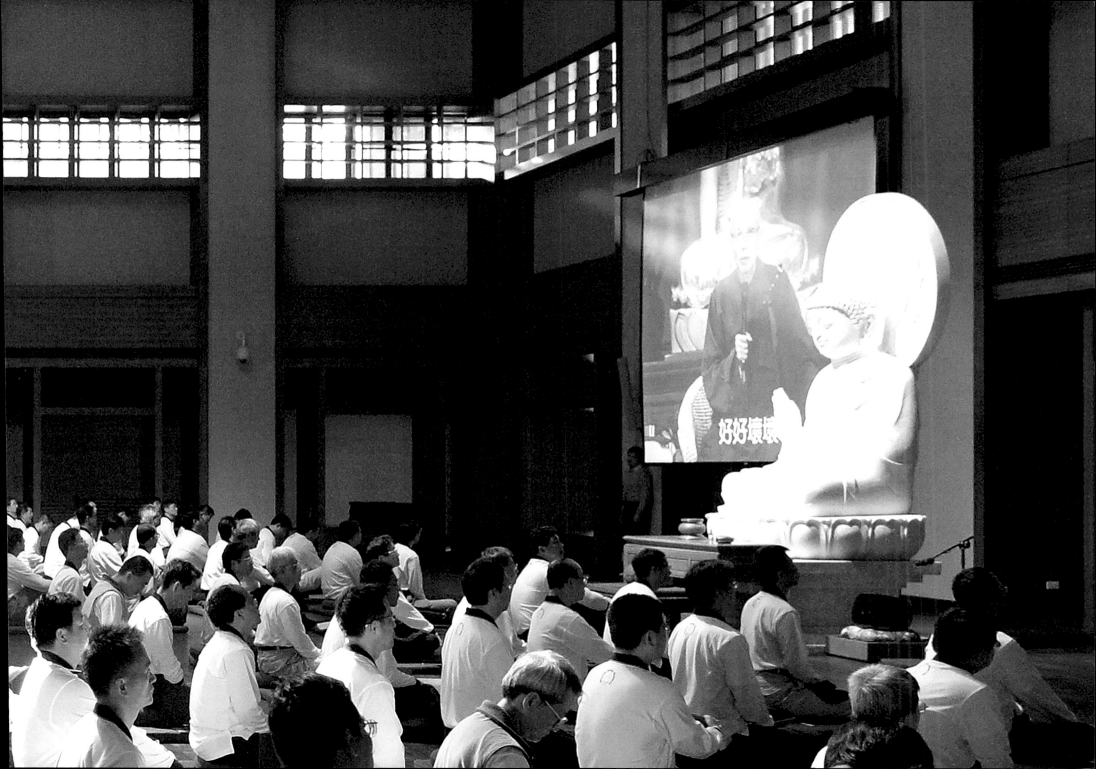

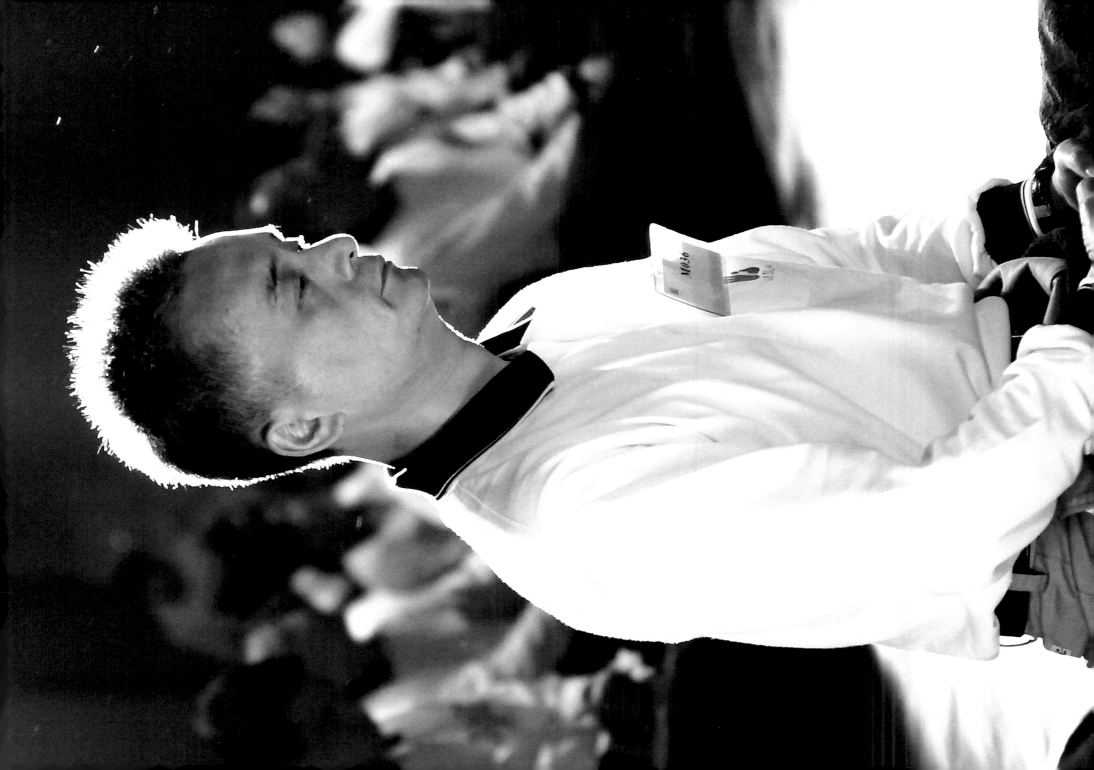

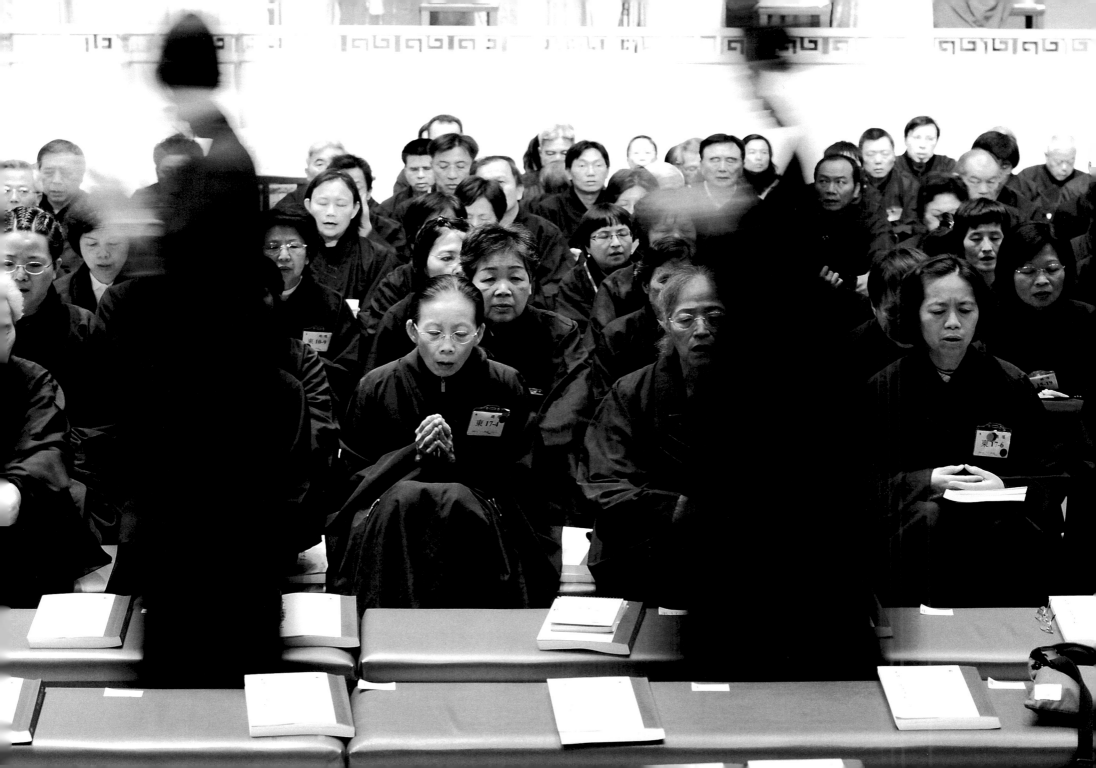

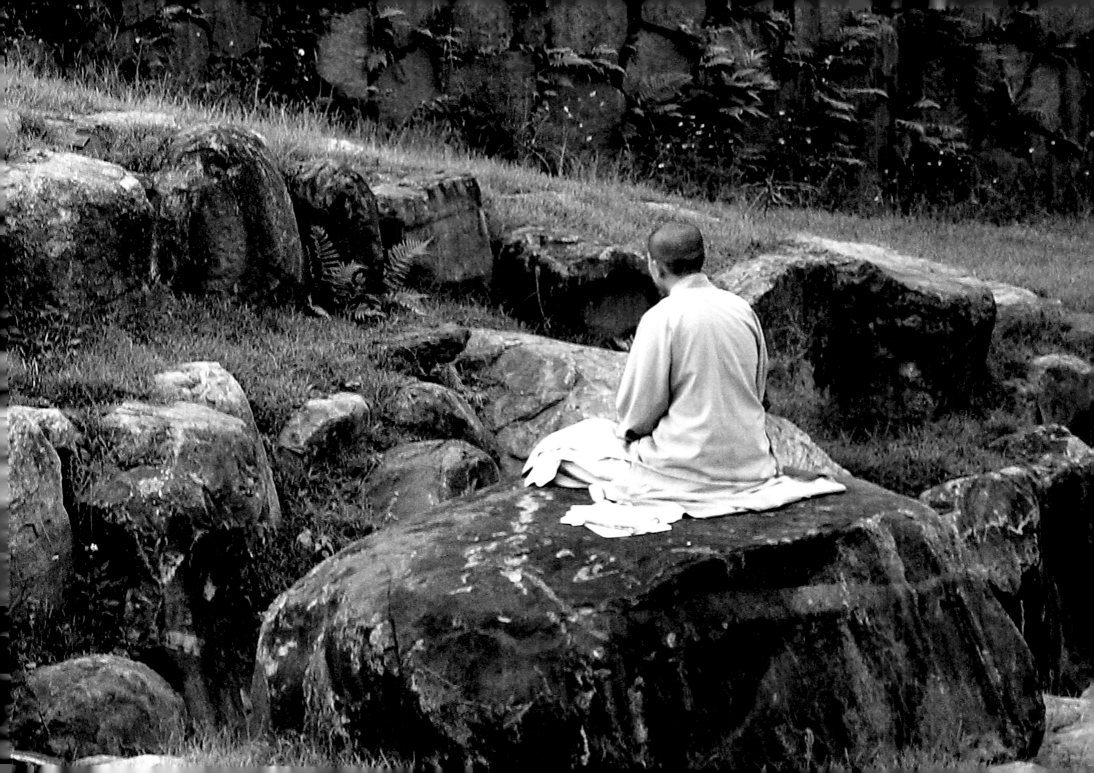

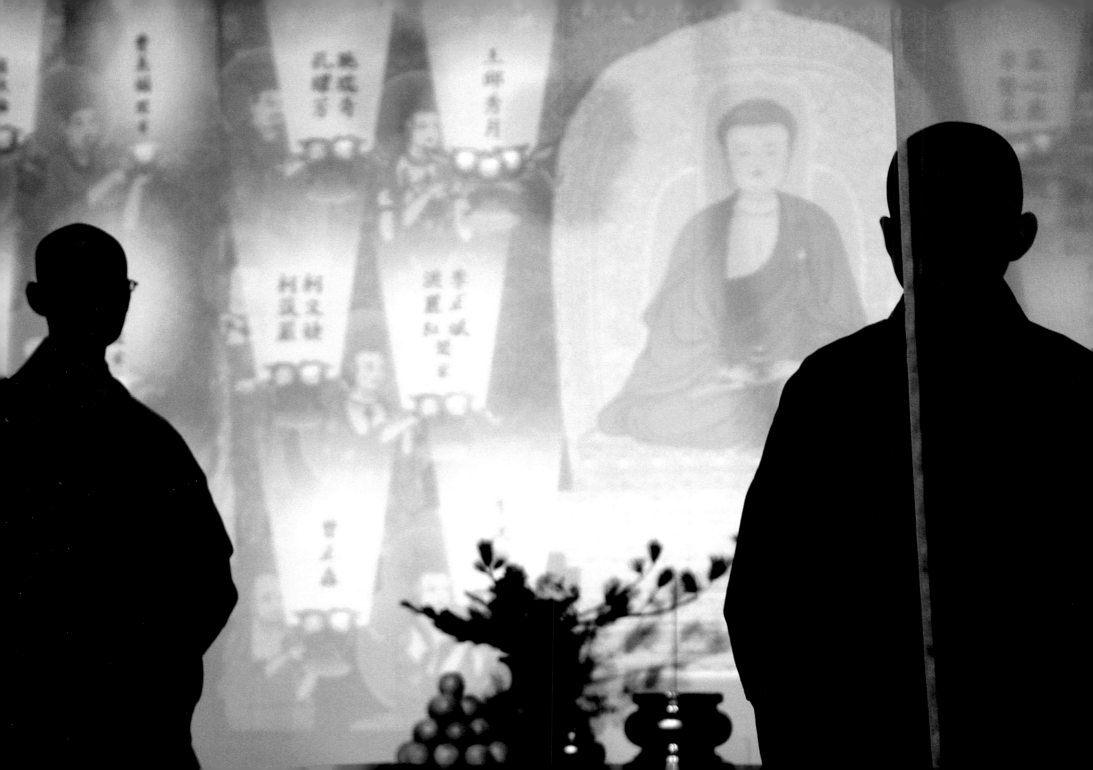

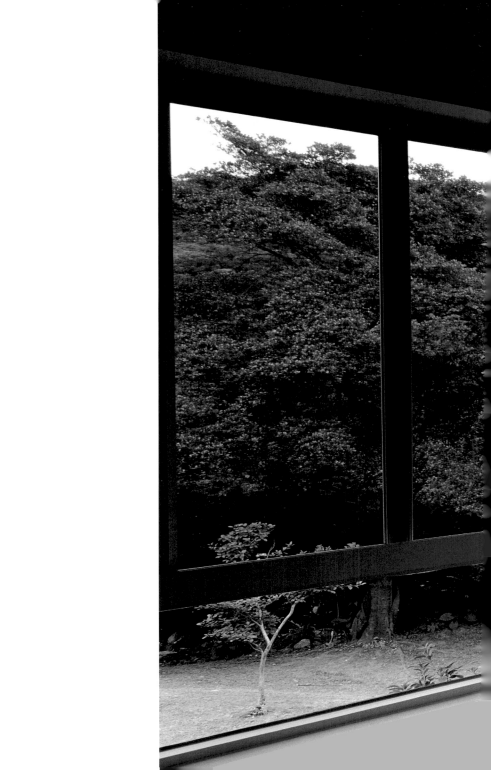

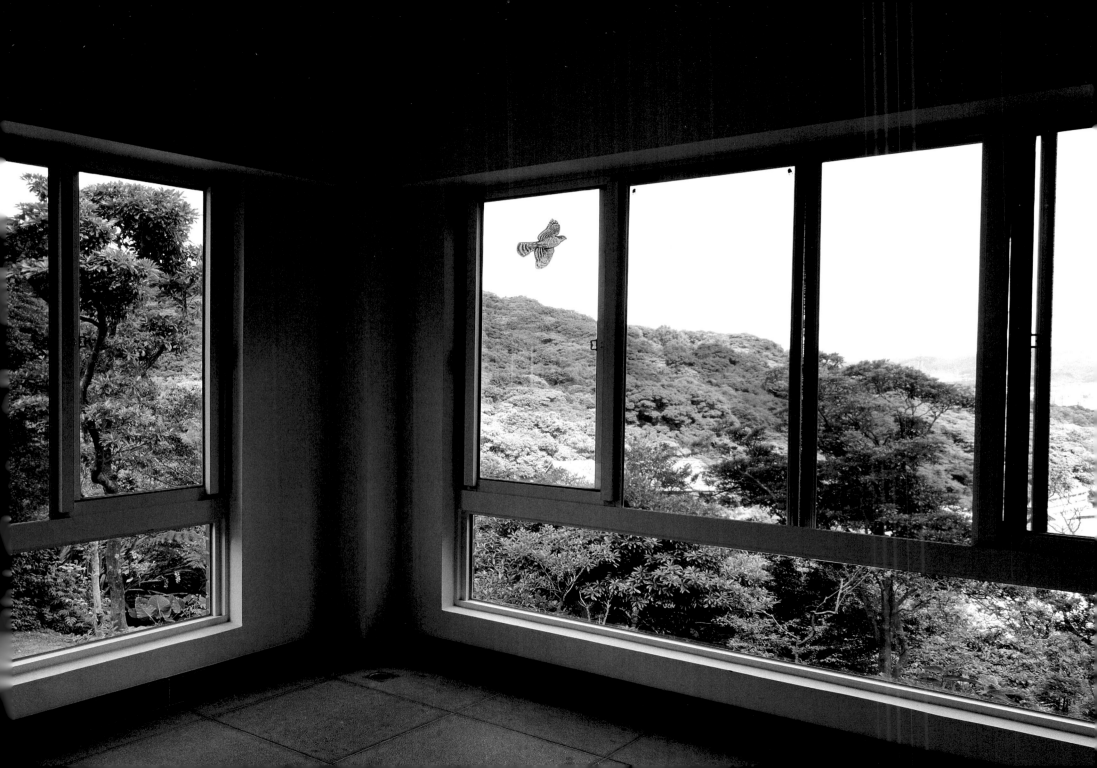

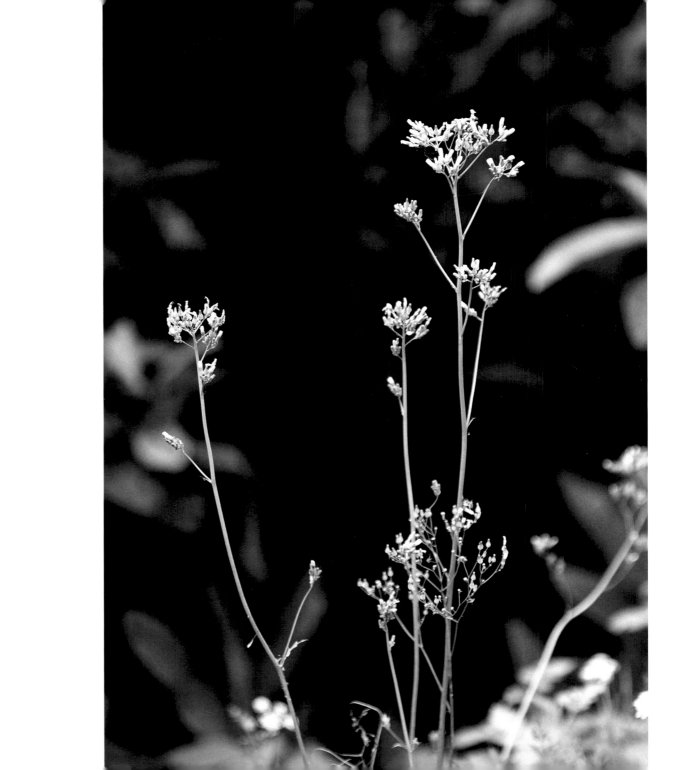

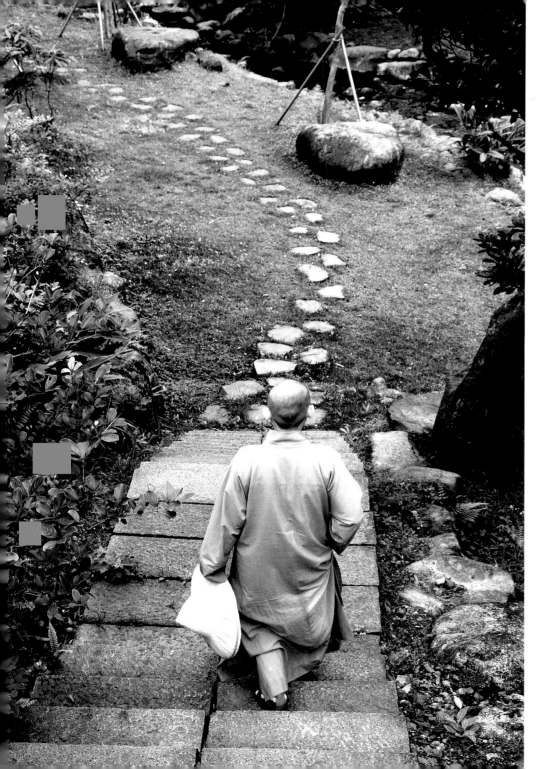
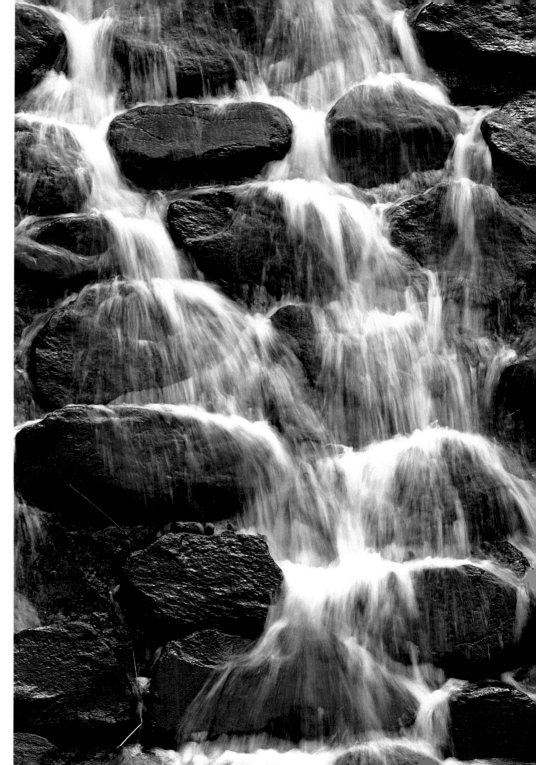

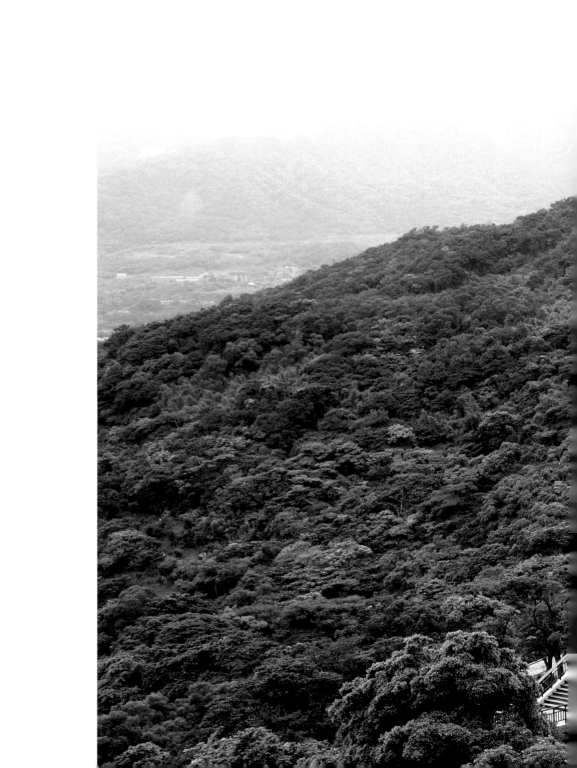

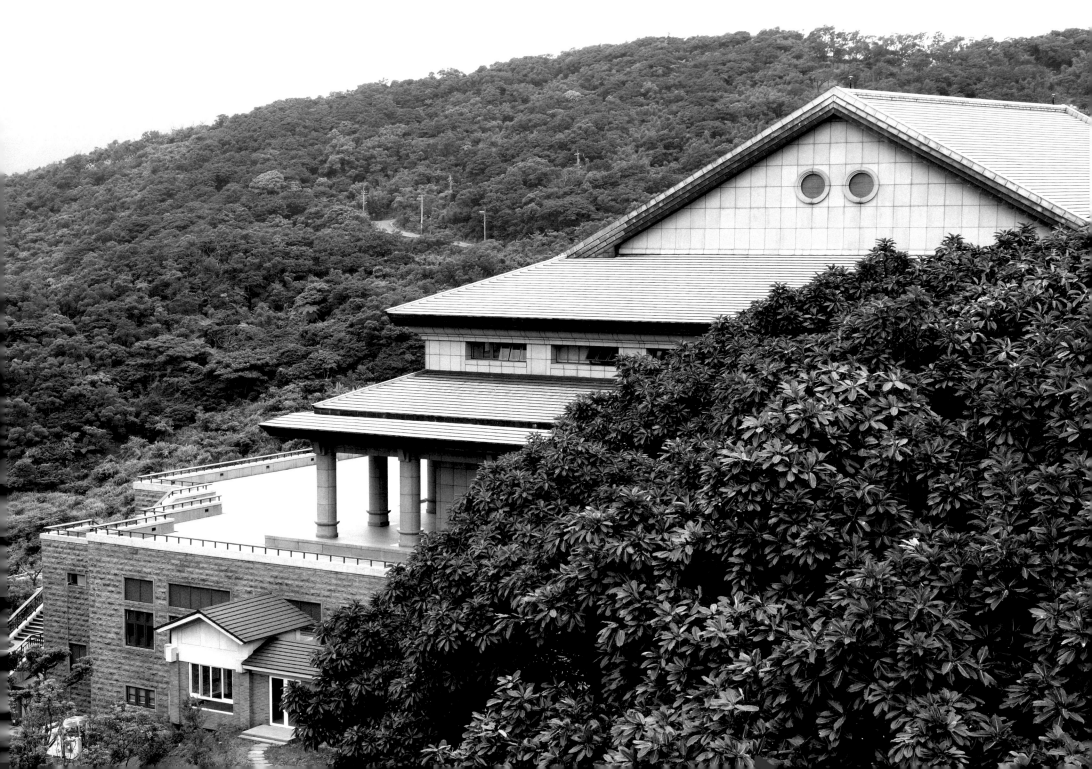

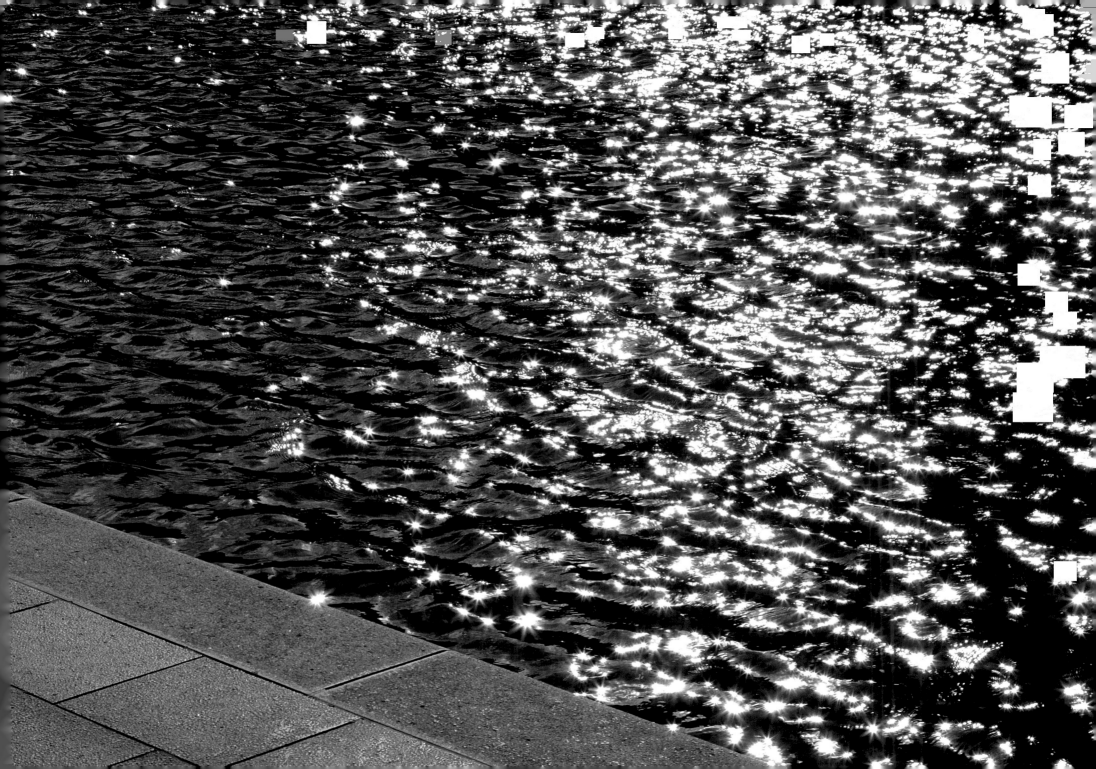

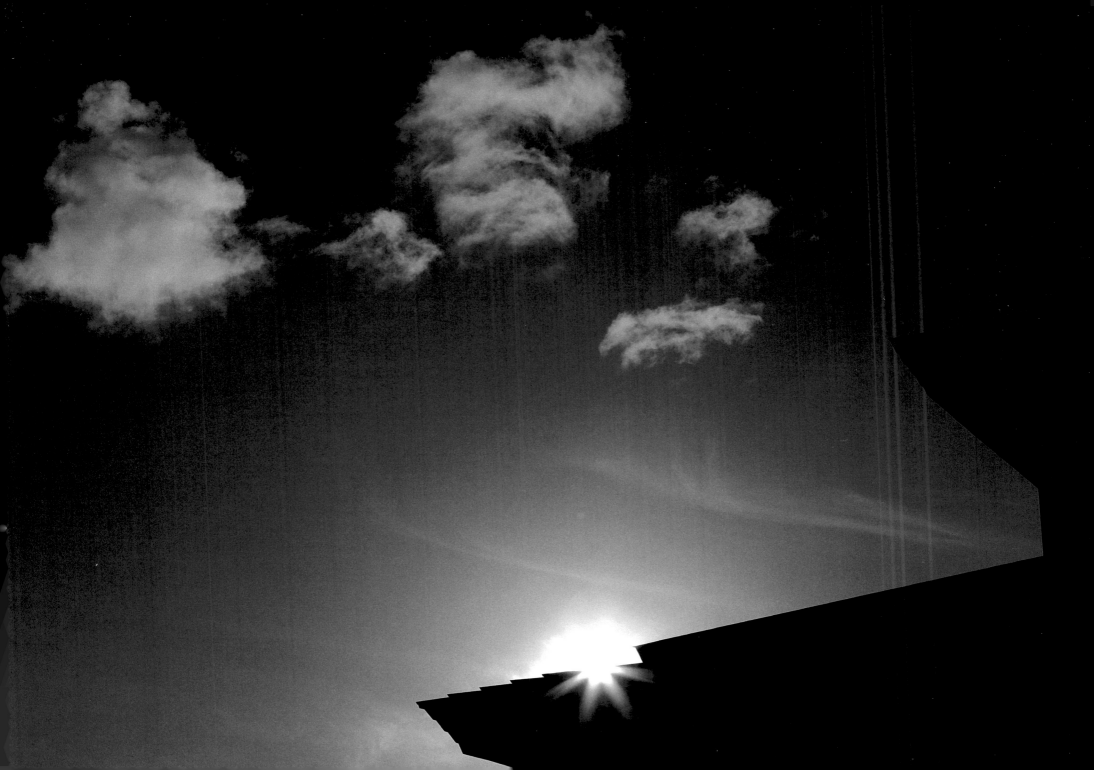

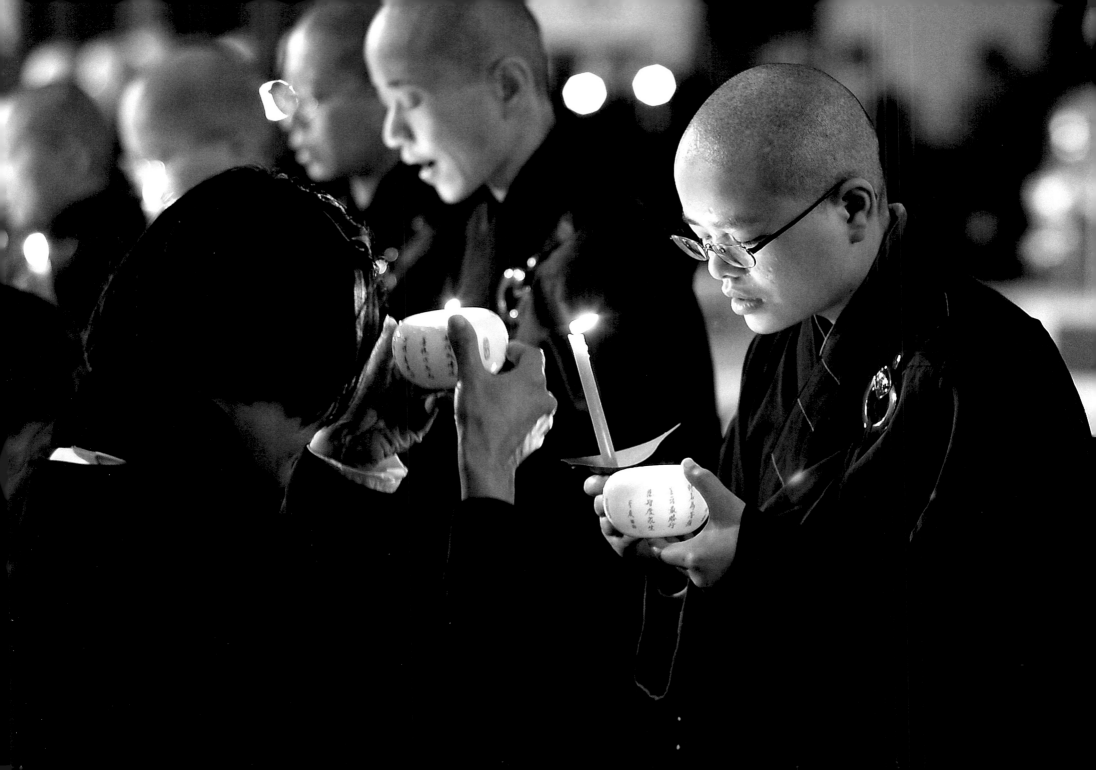

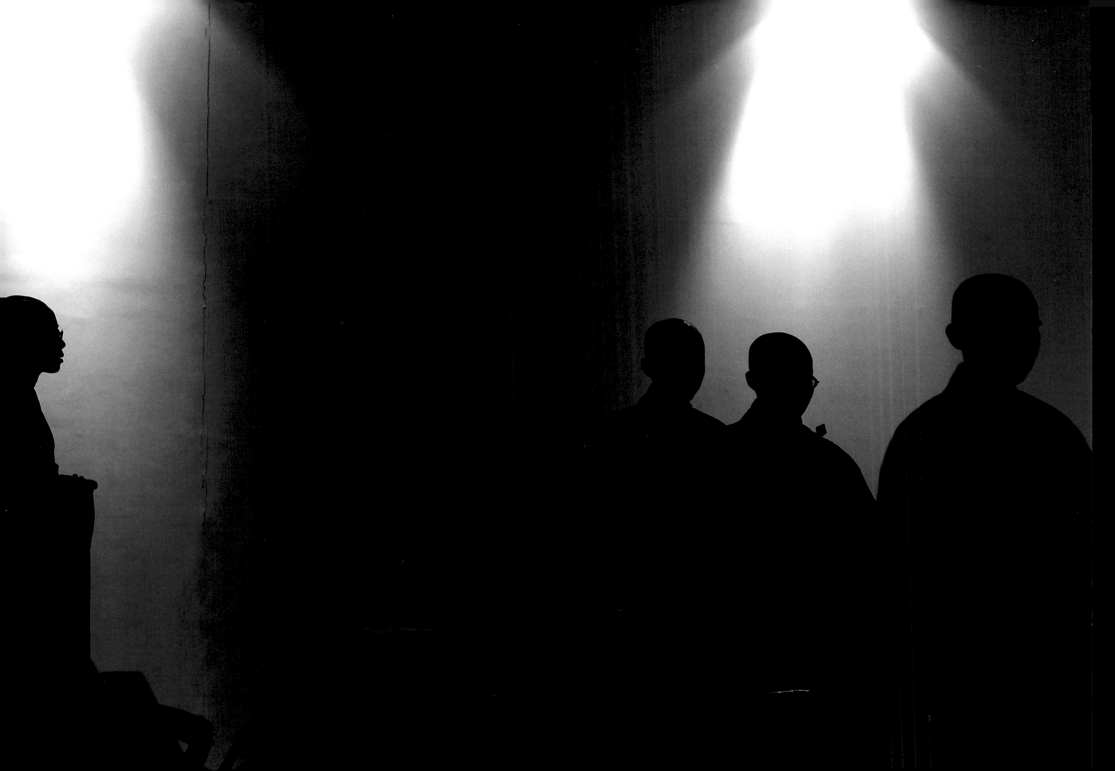

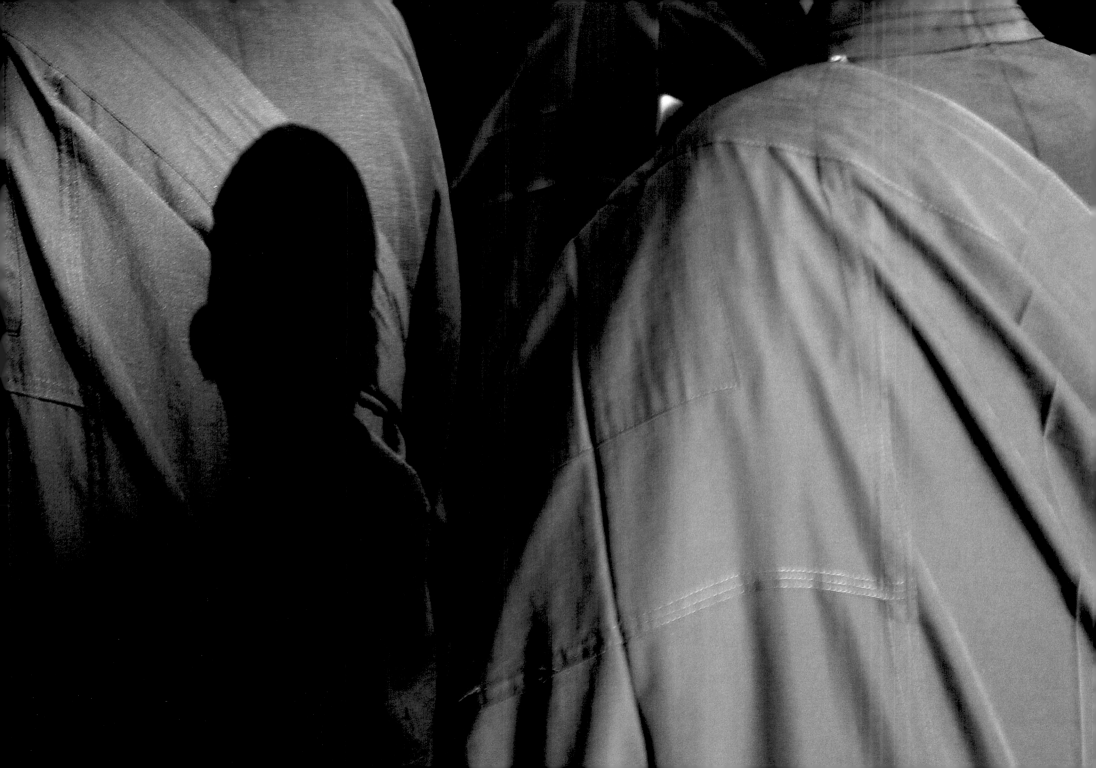

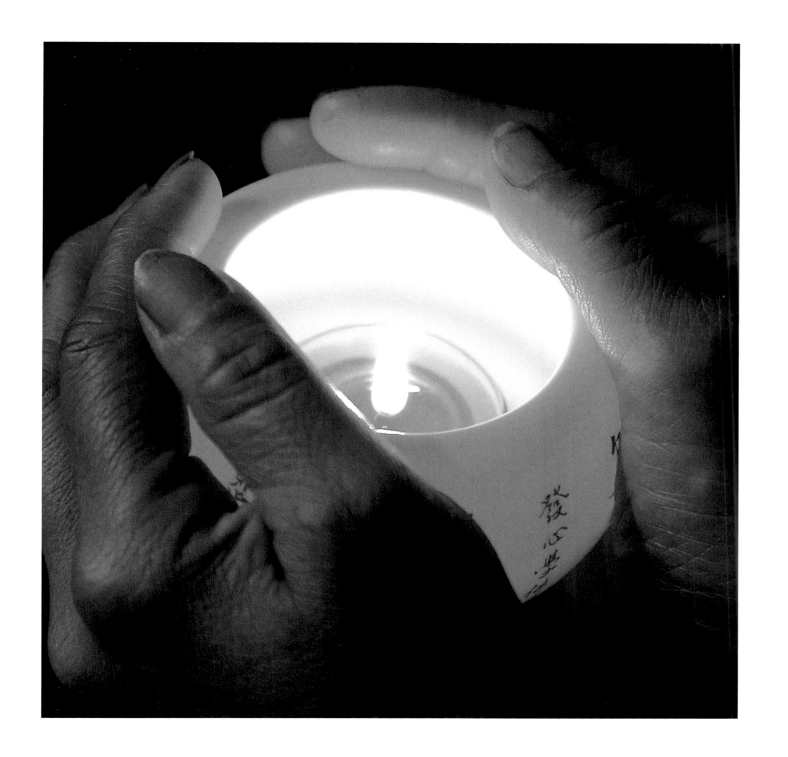

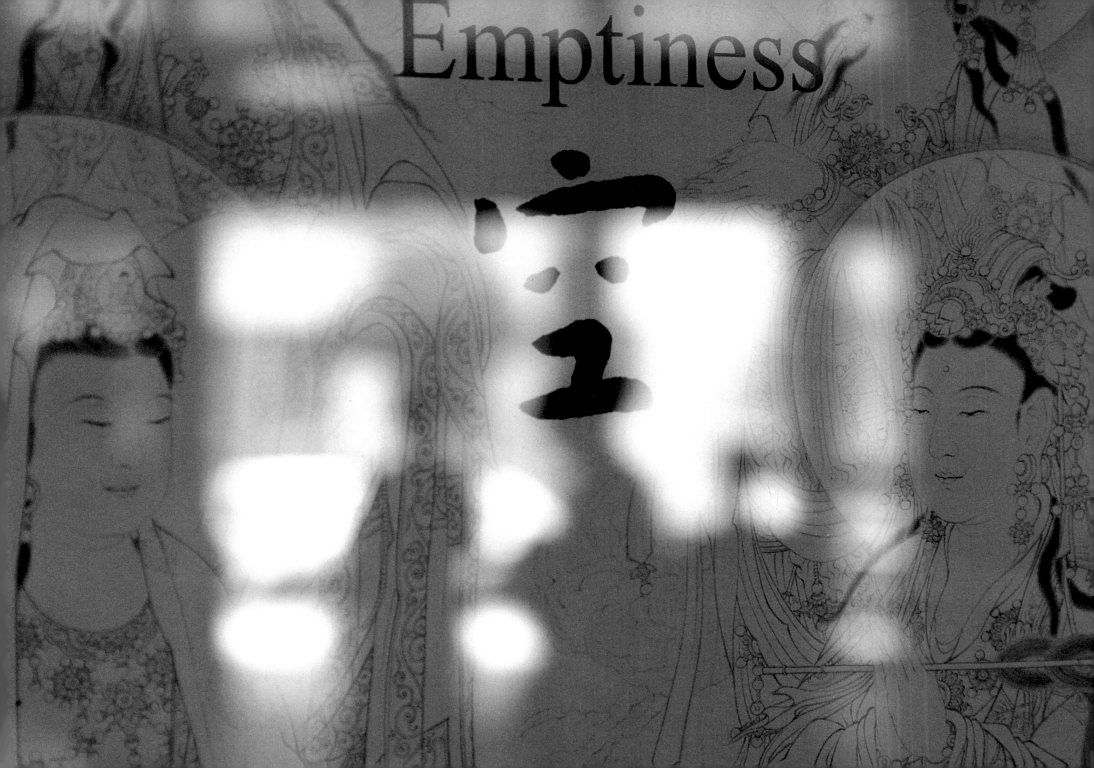

Emptiness

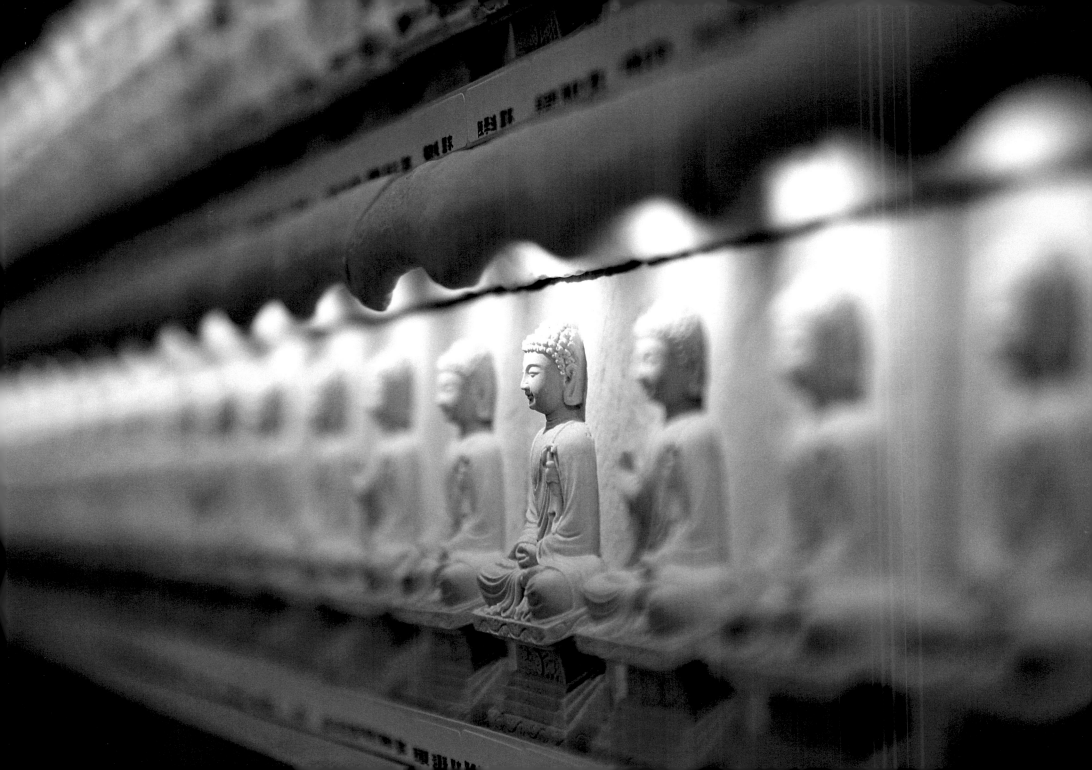

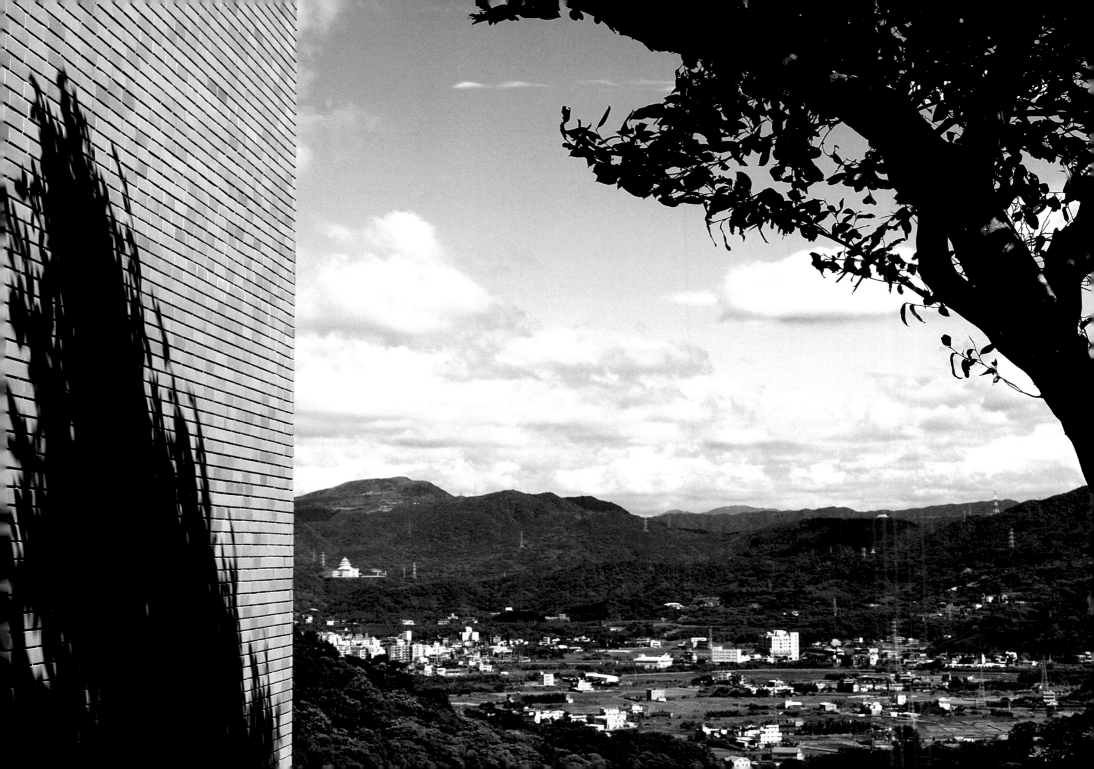

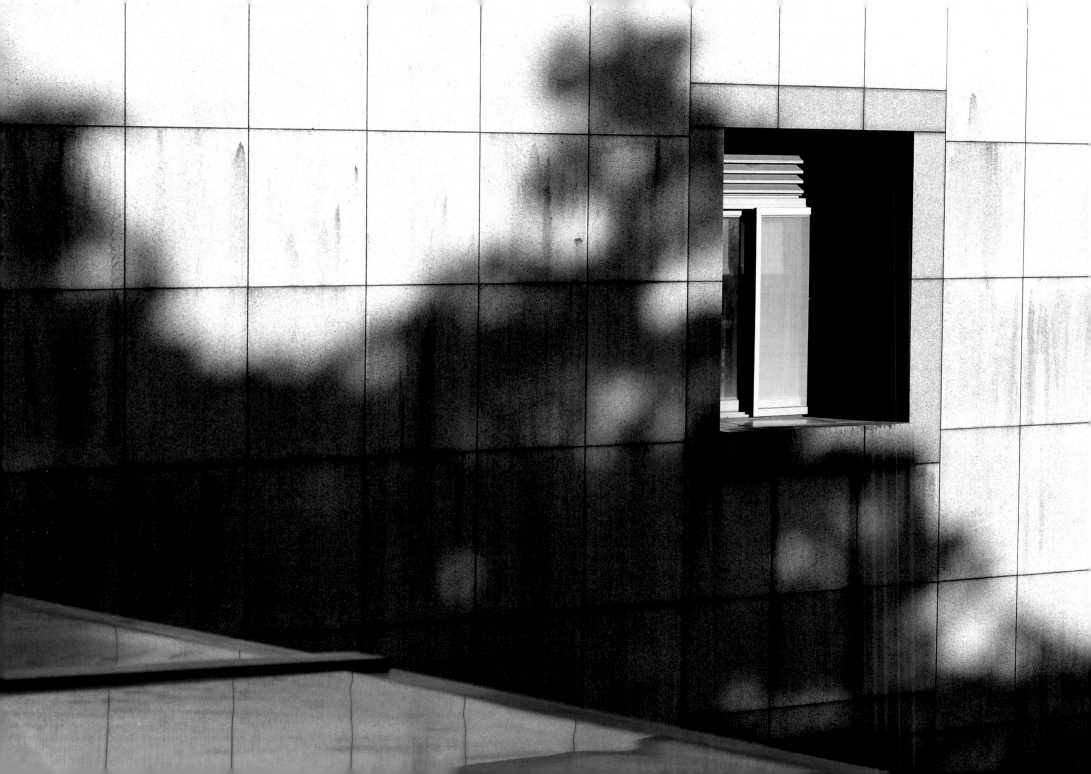

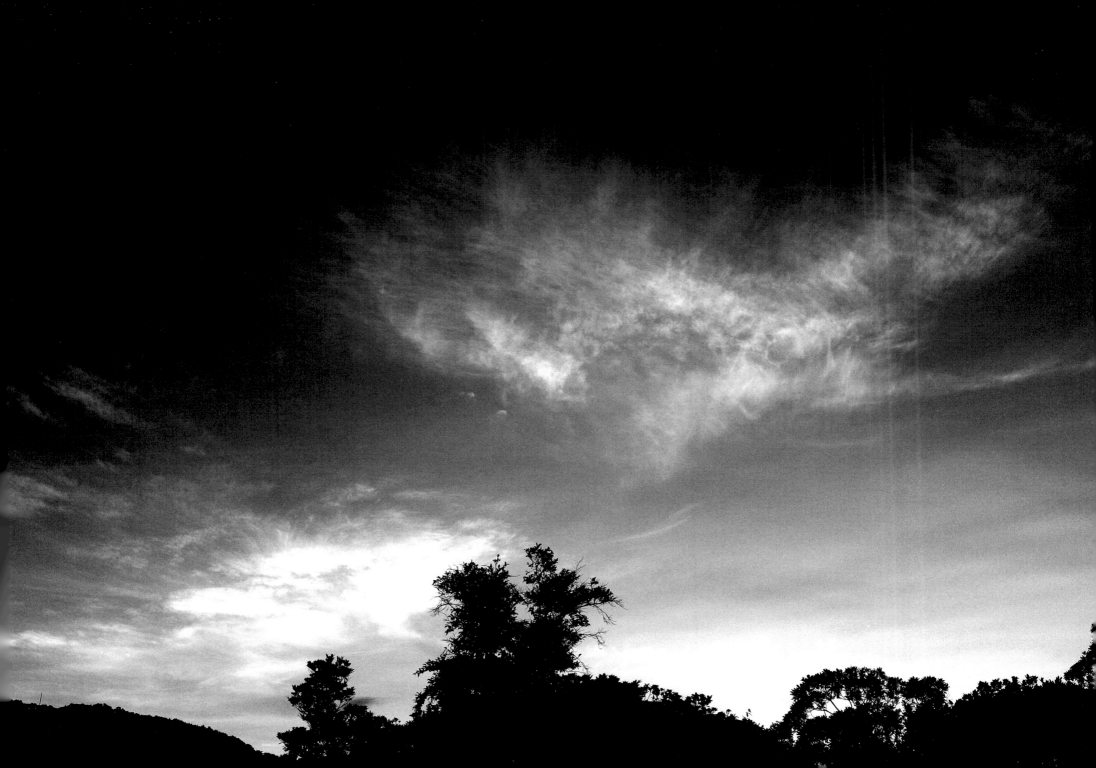

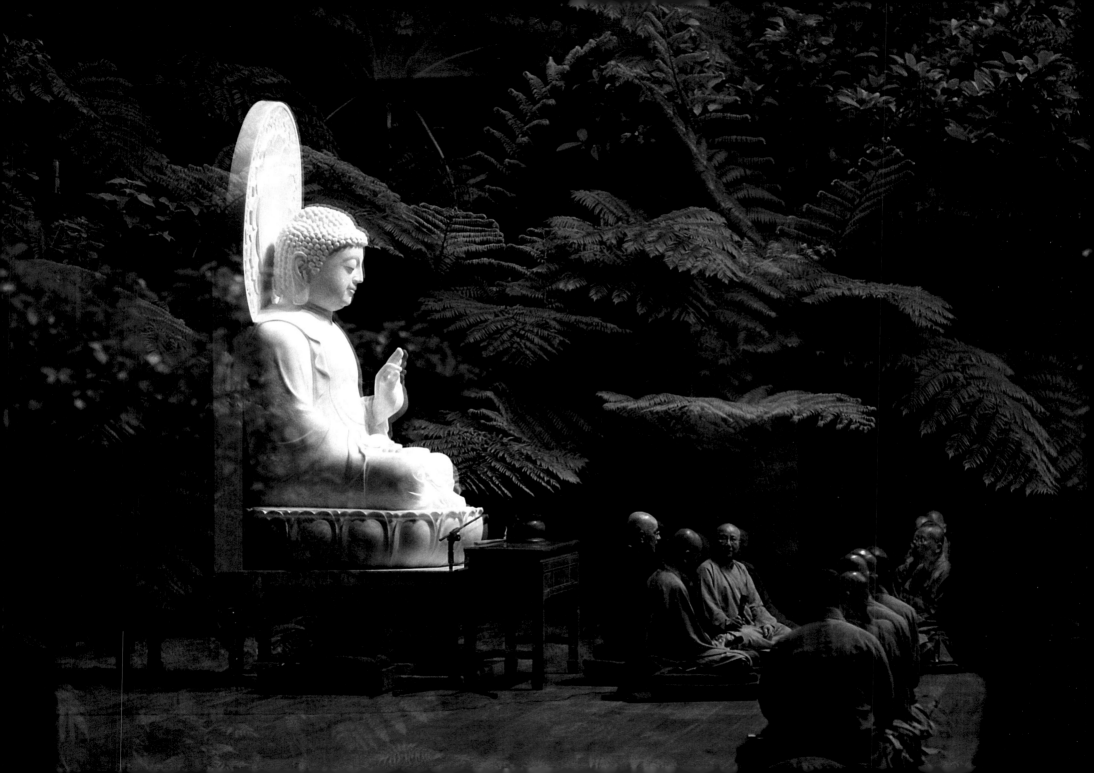

後　記

　　這本名為《Pure Land‧淨土》的攝影集，是我於 2010 至 2011 年在視丘攝影藝術學院研習時的作業之一。內容是基於我在法鼓山文化中心擔任特約攝影的期間所拍攝的照片為藍本，所編排出的作品。

　　《Pure Land‧淨土》以現代影像的藝術形式為媒介，企圖傳達佛法的旨趣與內涵。既表現我現階段對於佛法的「體悟」，對佛教攝影藝術的看法，也代表著我努力的歷程，與內心的探索。

　　我以一連串影像，取代單幅影像，做為一個作品單元。利用影像的前後脈絡及關聯，除了豐富影像的藝術性之外，內容由具象到抽象，從敘事到無題。代表著由「有」到「空」，由入世到出世的隱含意義。並且利用譬喻、暗示、影射等方式，表達其不可言說的境界。

　　淨土是佛教的理想世界。攝影集中前後連貫的影像，暗示著佛陀的教誨：我們凡夫唯有不斷地修行，才能從五濁惡世超脫，到達清淨理想的淨土。

　　我認為，凡是從事佛教藝術創作的作者，必須對佛法的修行投入生命，進而焠鍊出對佛法的見解，才能創作出與佛法相應的作品。

　　我首先要感謝沈昭良老師的專題製作課程，讓我開始以法鼓山為專題，並且提供了嚴格的訓練與指導。另外我要感謝視丘攝影藝術學院的吳嘉寶老師，他的影像書寫課程讓我對影像的思維產生革命性的改變，同時也提供了照片選擇及編排的建議，讓這本攝影集成真。最後，要感謝法鼓山文化中心副都監果賢法師，他不但給我機會在法鼓山文化中心擔任特約攝影，也讓這本攝影集得以出版，讓我銘感五內。

Epilogue

My photo book, entitled *Pure Land*, is one of the assignments for my study at the FOTOSOFT Institute of Photography, Taipei, Taiwan, in 2010 and 2011, with photographic works taken during the time when I was serving as a contracted photographer at Dharma Drum Mountain Cultural Center.

Pure Land aims to convey the Buddhist element and essence by means of contemporary imagery art, reflecting my personal realization of the Dharma at the time and my point of view regarding Buddhist photographic art, and also representing the process of my personal development and internal exploration.

Instead of using separate single photos, a series of images are put together to form a work theme, according to their context and interrelation, thereby enriching their artistic quality as photo images. Ranging from the concrete to the abstract, from the descriptive to the untitled, these photos indicate the implicit meaning of transformation from "existence" to "emptiness" by transcending the mundane world. The skills of metaphor, implication, and allusion are used to express the state of being beyond verbal description.

In Buddhism, a Buddha's Pure Land is an ideal world. The photo book's focus on interrelated photos reflects the Buddha's teaching that only through incessant practice can ordinary beings transcend the evil world of five turbidities and realize the ideal pure land in its true sense.

As far as I am concerned, people engaged in Buddhist art creation also need to devote themselves to Buddhist practice, develop and refine their understanding of the Dharma, thereby creating works that carry Buddhist characteristics.

First of all, I'd like to thank Shen Chao-Liang's Photography Project course, which offered me serious training and guidance, and inspired me to base my project on Dharma Drum Mountain. Moreover, I'd like to thank Wu Jiabao, teacher at the FOTOSOFT Institute of Photography, who has revolutionarily transformed my views on photo images through his Photo Literacy course, and has offered me advice on selecting and compiling photos for this photo book. Finally, I'd like to extend my heartfelt thanks to Ven. Guoshyan, managing director of Dharma Drum Mountain Cultural Center, for kindly offering me the opportunity to serve as the contracted photographer at the Center, and facilitating the publication of this book.

あとがき

この『Pure Land・浄土』と題する写真集は、私が2010年から2011年に視丘撮影芸術学院で学んでいた時の課題のひとつで、法鼓山文化センターで特任カメラマンを務めていた期間に撮影したものを土台に編集したものです。

『Pure Land・浄土』は現代写真の芸術形式を仲立ちとして仏法の趣旨や内包するものを伝えようと試みたものです。私の現時点での仏法に対する「体悟」や仏教写真芸術に対する考えを伝えるものであるのみならず、私のこれまでの努力の道のり、内心における探究や模索を表すものでもあります。

私は一枚一枚の写真の代わりに、一連の写真を一作品としました。そこで写真同士の前後のつながりや関係性を利用し、写真の芸術性を高めるほかに、具体的なものから抽象的なものまで、そして叙事的な内容から無題のテーマまでをも表しました。ここにはまた「有」から「空」へ、俗世に入りそしてまた抜け出すという隠された意義があります。さらに比喩、暗示、示唆などの方法を用い、ことばでは言い尽くせぬ境地を表現しました。

浄土は仏教の理想世界です。写真集で前後緊密に相連なった写真は、仏陀の教えを暗示しています。私たちのような凡夫は不断に修行をすることによってでしかこの五濁悪世を抜け出し清らかな理想の浄土へは到達できない、ということです。

およそ仏教芸術の創作に携わる者は、仏法修行に命を預け、苦しみぬいて仏法への理解を得ることでようやく仏法にふさわしい作品を生み出せるのだと私は思います。

ここでまず、ドキュメンタリー写真の授業を担当する沈昭良先生に深く感謝します。私が法鼓山をテーマにするきっかけとなり、また厳しくご指導ご鞭撻くださいました。次に視丘撮影芸術学院の呉嘉宝先生に感謝します。呉先生のフォト・リテラシーの授業は、私の写真に対する考えに革命的な変化をもたらしました。さらに写真の選定や編集へのアドバイスもくださり、この写真集を実現させてくださいました。そして最後に、法鼓山文化センター特任カメラマンという機会をくださったうえ、この写真集の出版までしてくださり、私の心に深く感銘を残した法鼓山文化センター副都監の果賢法師に感謝申し上げます。

PURE LAND · 淨土 —— 許朝益攝影集

PURE LAND —— Photo book by Charles Hsu

攝　　　影：許朝益
英文譯者：張家誠
日文譯者：荒木達雄
出　　　版：法鼓文化

總　　　監：釋果賢
總　編　輯：陳重光
編　　　輯：張晴
校　　　對：許朝益、侯鵬暉
美術設計：許朝益、邱淑芳
地　　　址：112 臺北市北投區公館路 186 號 5 樓
電　　　話：02-2893-4646
傳　　　真：02-2896-0731
網　　　址：http://www.ddc.com.tw
E-mail：market@ddc.com.tw
讀者服務專線：02-2896-1600
初版一刷：2015 年 5 月
建議售價：新臺幣 480 元
郵撥帳號：50013371
戶 名：財團法人法鼓山文教基金會—法鼓文化
北美經銷處：紐約東初禪寺
Chan Meditation Center (New York, USA)
Tel: 718-592-6593 Fax: 718-592-0717

法鼓文化

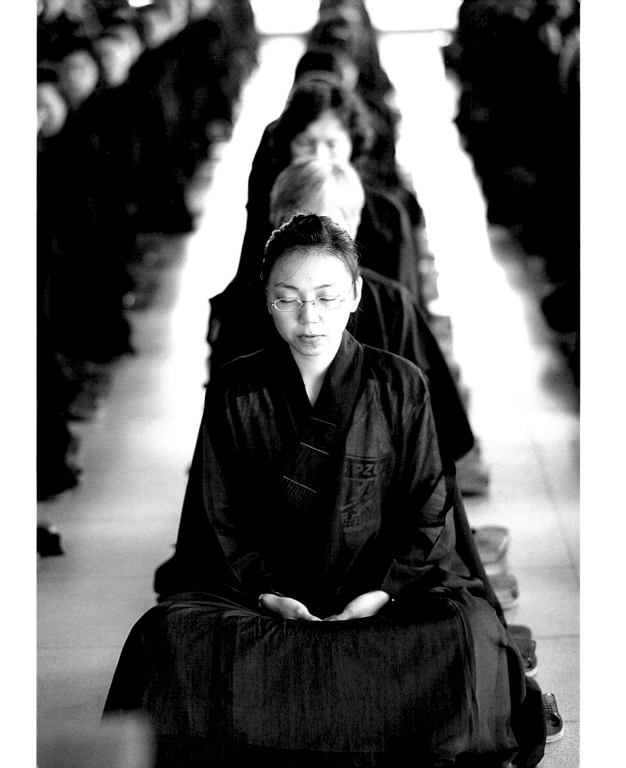